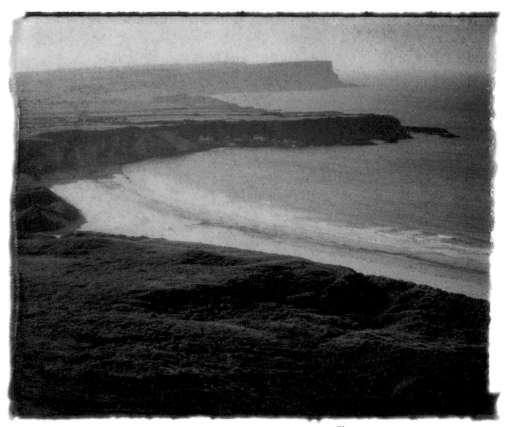

Cove, Minard Head

IRISH DREAMS

Photographs by Steven Rothfeld
Introduction by Edna O'Brien

CHRONICLE BOOKS
SAN FRANCISCO

For my muse, Susan

Photographs copyright © 1997 Steven Rothfeld
Introduction copyright © 1997 Edna O'Brien
Designed and packaged by Jennifer Barry Design, Sausalito, CA
Edited by Blake Hallanan
Calligraphy by Jane Dill

Library of Congress Cataloging-in-Publication Data
Rothfeld, Steven.
Irish Dreams: photographs / by Steven Rothfeld :
introduction by Edna O'Brien. —1st ed.
p. cm.
Includes bibliographical references.
ISBN 0-8118-1985-X
1. Ireland—Pictorial works. I. Title.
DA982.R68 1997 97-4474
941.5—dc21 CIP

Distributed in Canada by
Raincoast Books
8680 Cambie Street
Vancouver, B. C. V6P 6M9

1 3 5 7 9 10 8 6 4 2

Chronicle Books
85 Second Street
San Francisco, California 94105

Printed in Hong Kong

Web Site: www.chronbooks.com

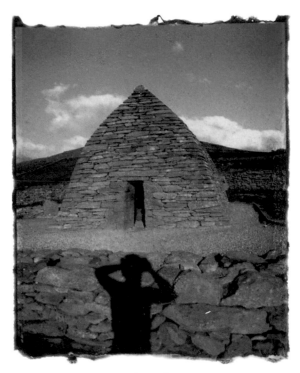

Gallarus Oratory

INTRODUCTION

In this enchanting book there is a quotation from Giraldus Cambrensis,
a twelfth-century typographer who believed Ireland to be separated from
the rest of the known world. In a sense, that is still true regardless of
tourism, television, computerism and all the other windfalls of civilisation.
Now why is this — why is Ireland separated somewhat from the rest of the
world? I think partly because the landscape and therefore the people are so
multi-faceted, everchanging and yet, more than any other place I know,
Ireland seems to have retained a sort of psychic and cosmic sense of the past.
This is not simply an obdurate preoccupation with history, it is a recogni-
tion of a place permeated by some kind of otherness, receding back, back.

Maybe this is one of the reasons why Ireland has produced so many
vigorous writers, all of whom, in their own sweet way, no doubt believe that
they speak specially for her. Yet all of them vastly differ. There is a song
about the forty shades of green which could also be said of the legacy of
fiction and poetry which her bards have bequeathed. In this collection, W. B.
Yeats quite rightly lays claim to his ancestral stair while J. M. Synge, who
regretted any moment that he spent out of Ireland, depicts the grey and
wintry glens in his work, but to combat that greyness he peoples his

fabulous plays with men and women possessed of wild licentious imagina-
tions. James Joyce, who believed he was cutting all the umbilical sentiments
of the race, simply re-created them in a more labyrinthine way and the
three quotations from him here make one tremble with admiration. Among
the living writers, Eavan Boland recalls the exiles' consuming longing while
Seamus Heaney wonders whether land or sea holds the sovereignty of the
Aran Islands. There is not a whiff of sentiment by any of the Irish writers,
but the visitors, perhaps because they had happier fates elsewhere, depict
a far sweeter and more limpid place. All are true because Ireland herself is
a changeling.

These photographs do not simply corroborate the words, they are little
illuminations in themselves. They are merry and mournful, comic and
poignant, dwelling on the everyday and the primordial, but if I am allowed
to single out two that seem to be the essence of that beautiful haunted and
vaulting country, I would pick the ones taken at the ruin in Gowran and
the Carran Church, because not only are they of actual places but the light
which they cast brings to mind the transcendental.

—Edna O'Brien

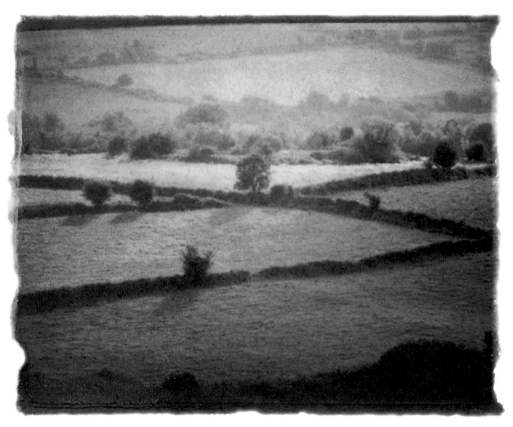

Landscape, County Cork

Your wits can thicken in that soft moist air,
on those springy white roads,
in those misty rushes and brown bogs, on those
hillsides of granite rocks and magenta heather.
You've no such colours in the sky, no such lure
in the distance, no such sadness in the evenings.
Oh the dreaming! the dreaming!
the torturing, heart scalding, never
satisfying dreaming, dreaming, dreaming.
~ George Bernard Shaw

So I have come . . .
where the fields are sharply green,
where a wild beauty hides in the glens,
where sudden surprising vistas open up
as the road rises and falls;
and here I smell for the first time
the incense of Ireland, the smoke of turf fires,
and here for the first time
I see the face of the Irish countryside.
—H.V. Morton

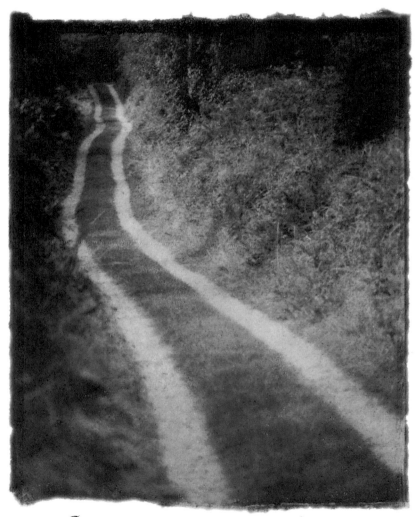

Country Road, Boggeragh Mountains

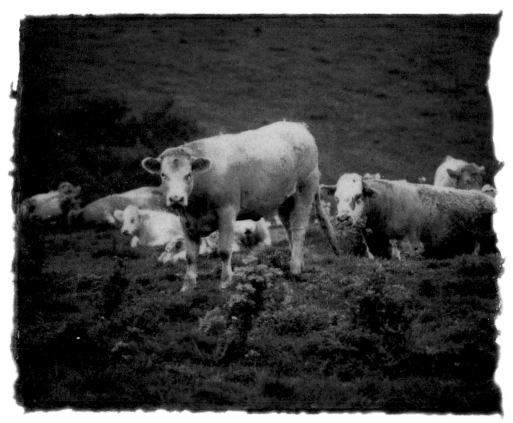

Cows, Durrus

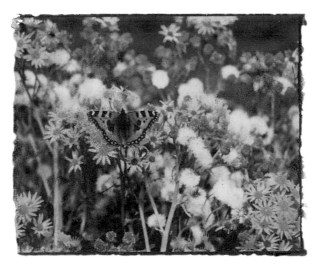

Butterfly, Old Head

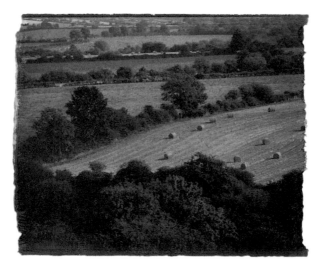

Landscape, Gortroe

The enchantment, on which you may not lay anything, so heavy as a hand, is made of atmosphere, of those indefinable things of wind and rain and cloud and sun between rain. Nowhere does light vary so constantly, or play such a part as a beautifier. —Pamela Hinkson

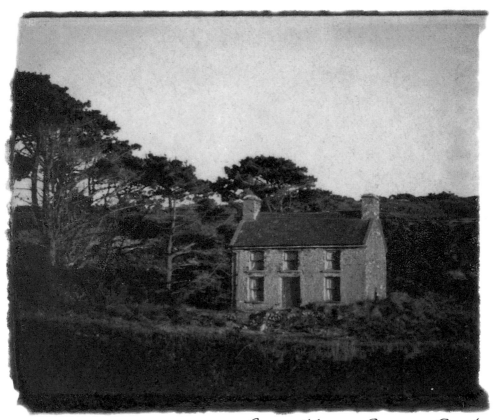

Stone House, County Cork

Ireland... separated from the rest of the known world, and in some sort to be distinguished as another world.
-Giraldus Cambrensis

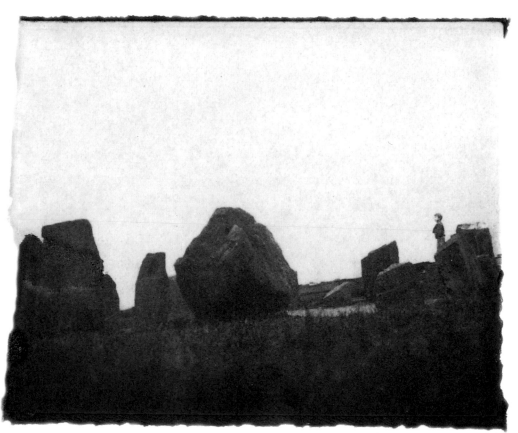

Dromberg Stone Circle, County Cork

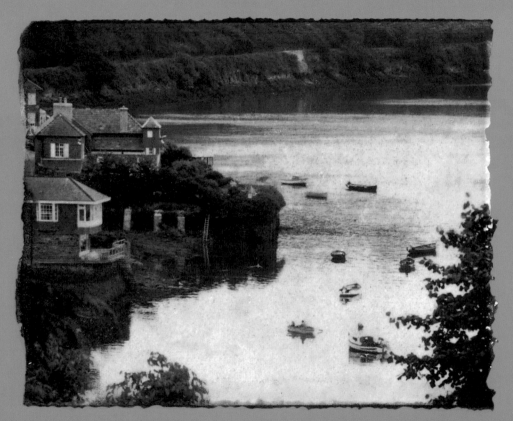

Harbour, Kinsale

Even over that spectacular place
a hint of sadness loiters.
Melancholy is endemic to Ireland.
The fragility of climate is part of it—
the sunshine so palely brilliant but so
ephemeral, the feeling, that the weather
is never set, but may shift in mood from
hour to hour. – Jan Morris

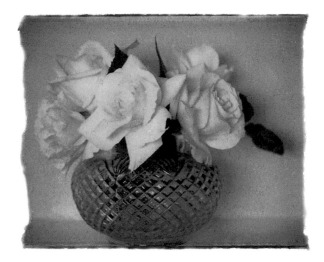

Roses

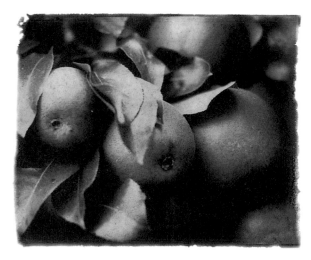

Pears

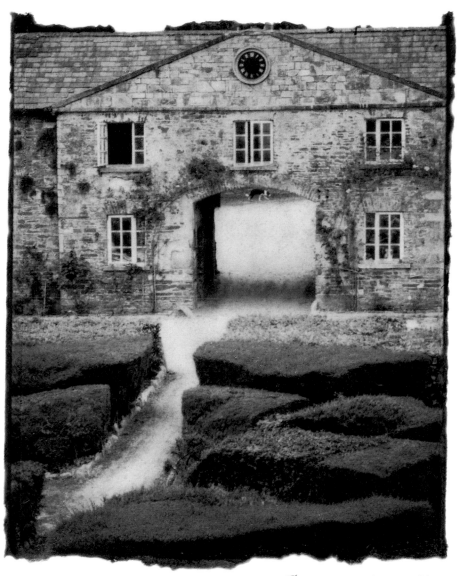

Courtyard, Mallow

The far·off hills are the greenest.
- Irish Proverb

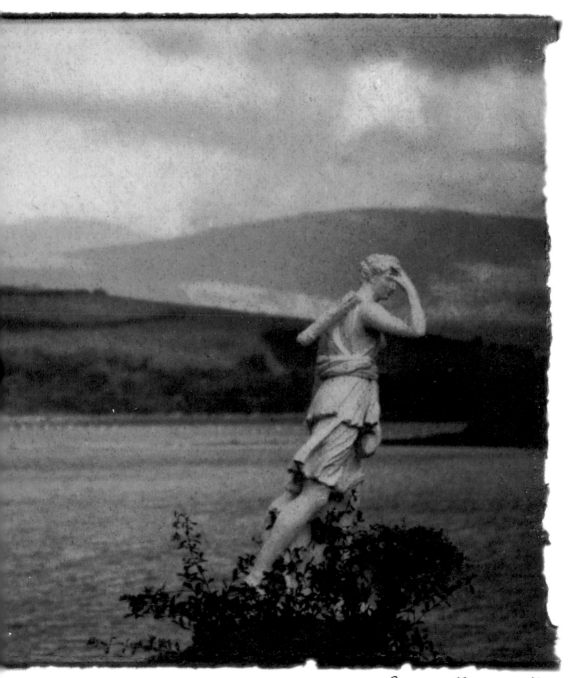

Statue, Bantry Bay

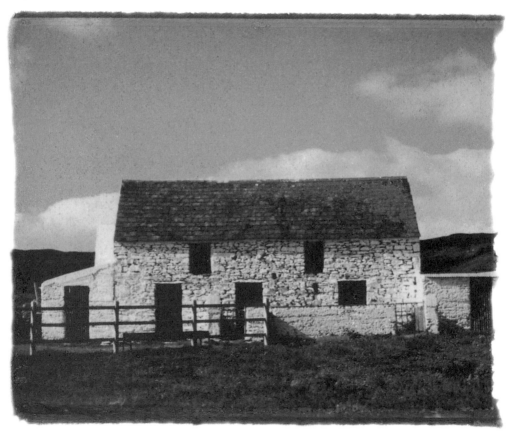

Farmhouse, County Cork

British Queens

Cobh.
Coming home.
I had heard of this:
the ground of emigrants
resistless, weeping,
laid their cheeks to,
put their lips to kiss
Love is also memory.
– Eavan Boland

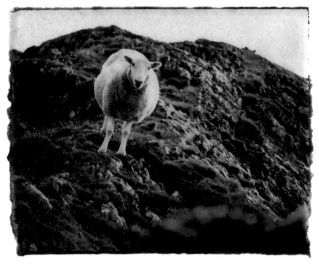

Ewe, Brow Head

God made the grass, the air and the rain; and
the grass, the air and the rain made the Irish;
and the Irish turned the grass, the air
and the rain back to God. – Sean O'Faolain

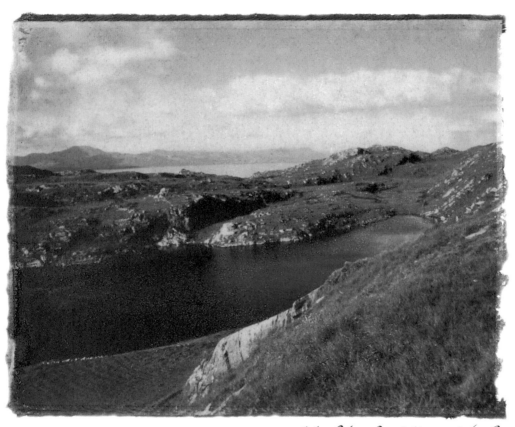

Headlands, Mizen Head

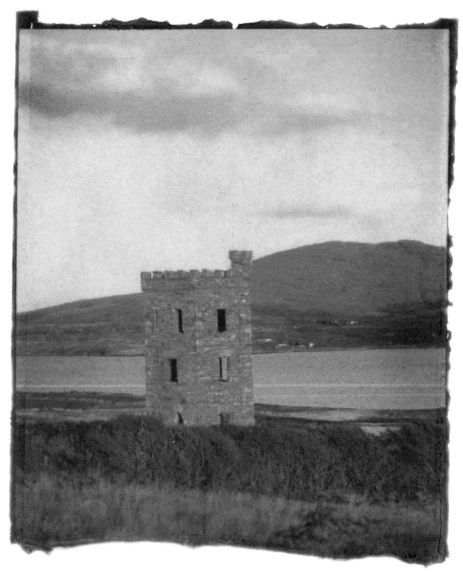

Castle, Glandore Road

All is a brushwork vision, a wash
Of new-laid colour. They come alive –
Fuchsia, grass, rock. The mist which had unfocused
Mountain and bay, is clean
Forgot, and gone the lumpish sag
Of cloud epitomizing
Our ennui. Storms have blown the sky to blue.
–Cecil Day Lewis

I declare this tower is my symbol;
 I declare
This winding, gyrating, spiring treadmill
 of a stair is my ancestral stair.
—William Butler Yeats

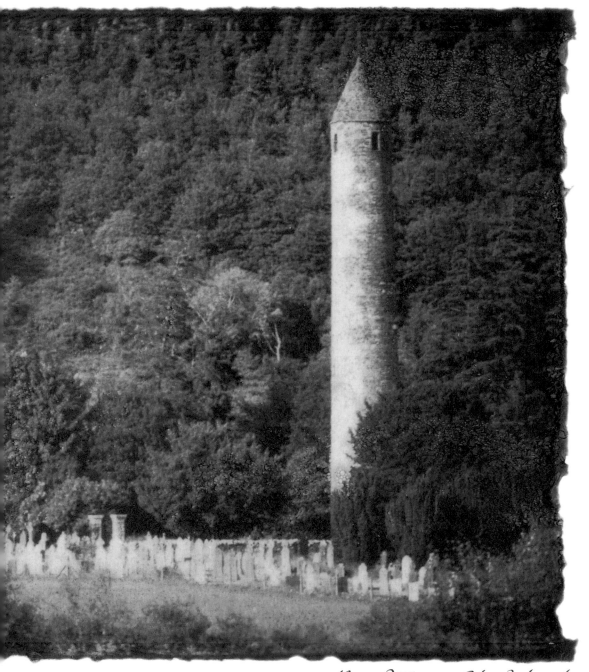

Round Tower, Glendalough

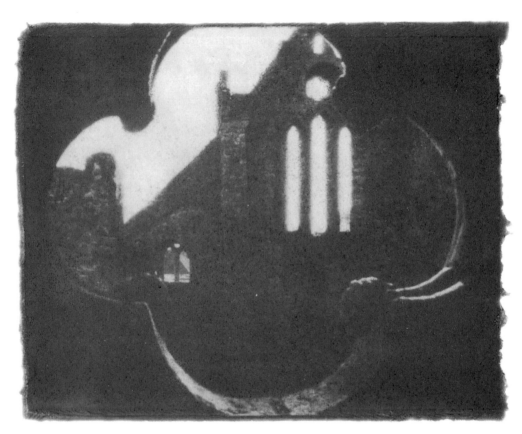

Quatrefoil, Gowran

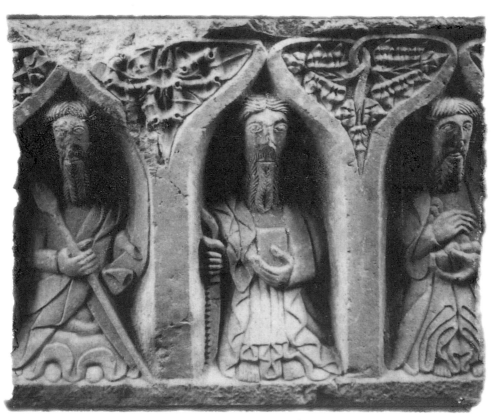

Saints, Jerpoint Abbey

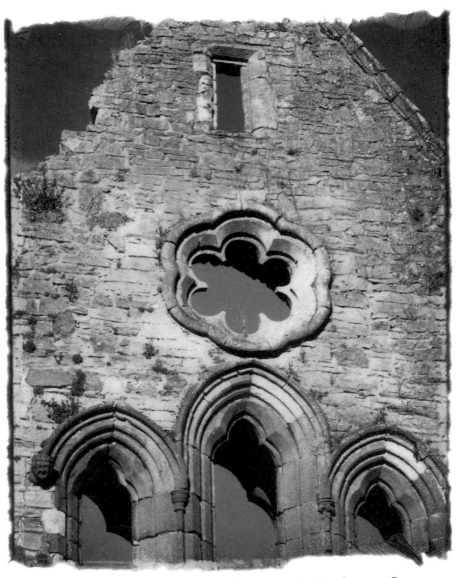

Lancet Windows, Gowran

Stonework will take the eye: the heart conceives
In the pure light from wall to whitewashed wall
An unseen presence, formed by the faith of all
The dead who age to age had worshipped here,
Kneeling, on grass along the roofless nave.
– Cecil Day-Lewis

Gravestone, Glendalough

In some parts of Ireland,
the sleep which knows no waking
is always followed by the wake
which has no sleeping.
– Mary Wilson Little

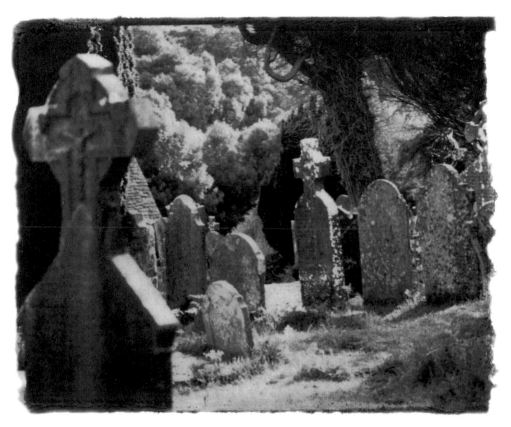

Graveyard, Glendalough

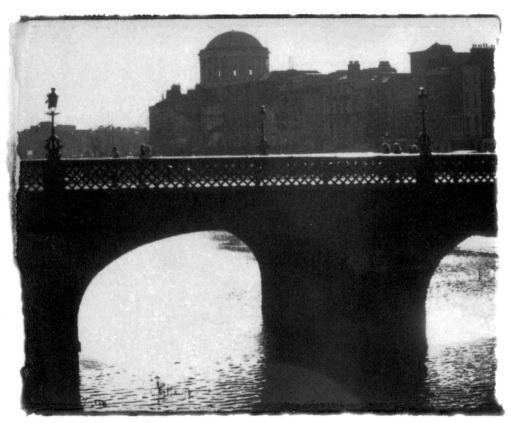

River Liffey, Dublin

A veiled sunlight lit up faintly the grey sheet
of water where the river was embayed.
In the distance along the course of the
slowflowing Liffey... the dim fabric of the city
lay prone in haze. Like a scene on some vague arras,
old as man's weariness, the image of the
seventh city of christendom was visible ...
across the timeless air. –James Joyce

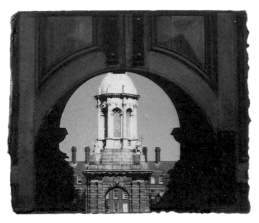

Trinity College, Dublin

O'Connell Street, Dublin

The wonder and miracle of Dublin is its compactness.
Within a radius of eight miles a man can have every experience
he would ever wish to enjoy. It is complete in itself.
Indeed it could be said that Dublin is not a city;
it is a lazy man's continent. —Anthony Butler

Parliament Street, Dublin

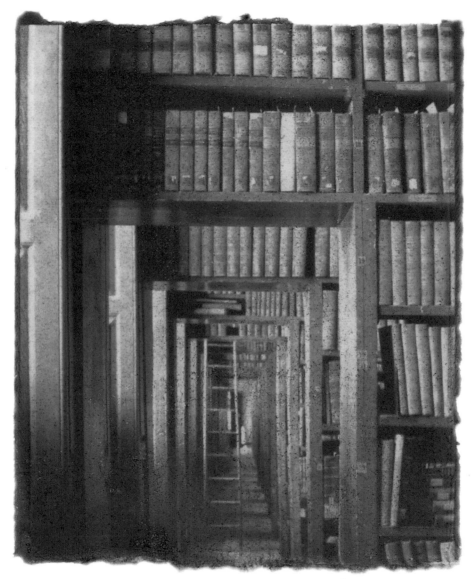

Trinity College Library, Dublin

Wherever they went the Irish brought with them their books, many unseen in Europe for centuries and tied to their waists as signs of triumph, just as Irish heroes had once tied to their waists their enemies' heads. Wherever they went they brought their love of learning and their skills in bookmaking. In the bays and valleys of their exile, they reestablished literacy and breathed new life into the exhausted literary culture of Europe.
- Thomas Cahill

Providence has balanced very lightly the Irish nature. It swings to a touch. Where heavier natures creep slowly up and down according to the weight or pressure of circumstance, the Celtic temperament leaps to the weight of a feather; and you have sullen depression, or irresponsible gaiety, murderous disloyalty or more than feudal fealty, in swift and sudden alterations.

– Canon P. A. Sheehan

Facade, the South

Facade, the North

Crown Liquor Saloon, Belfast

We have had a most garrulous time.
We never stop talking. The Irish are the
most gifted people in that line. After dinner
the innkeeper comes in and sits down
and talks till bedtime, perfect English,
much more amusing than any London society.
–Virginia Woolf

Victorian Glass, Belfast

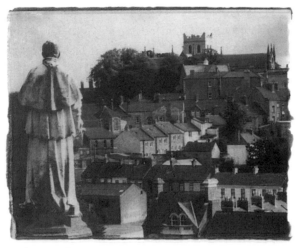

View from St. Patrick's, Armagh

There is a through·otherness about
Armagh of tower and steeple, up on the hill
are the arguing graves of the kings and
below are the people. - W.R. Rodgers

Its shapes and contours make of it
a paradise that is unhappy.
And so it must forever remain,
far away from the stream of life
and with the sadness of all things
that are a little remote from reality...
This green country on the edge
of the world, with nothing
beyond it. -Sacheverell Sitwell

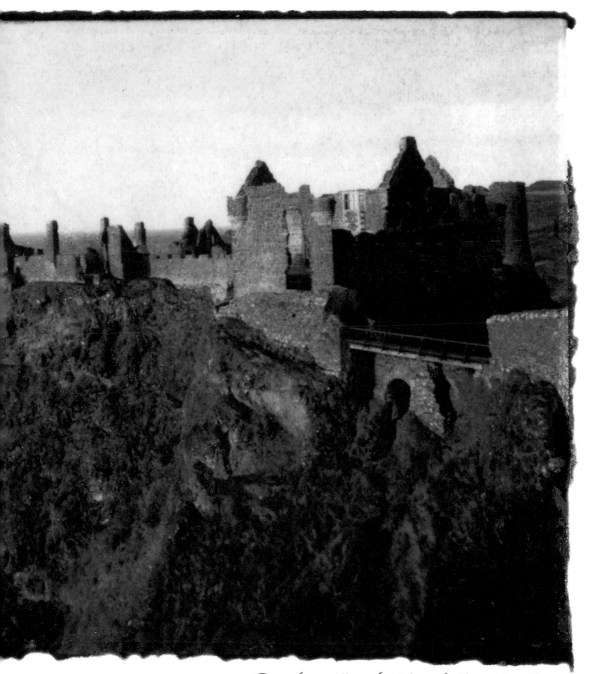

Dunluce Castle, North Antrim Coast

There is something inexpressibly weird
about those millions of mathematically
formed pillars which thrust themselves
upward at the edge of the sea....
I have never seen stones that so closely
resemble iron or steel. The Causeway
has a queerly modern look! It is Cubist.
-H. V. Morton

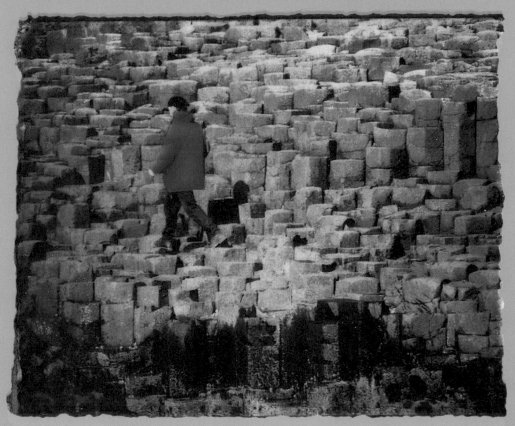

Giant's Causeway, North Antrim Coast

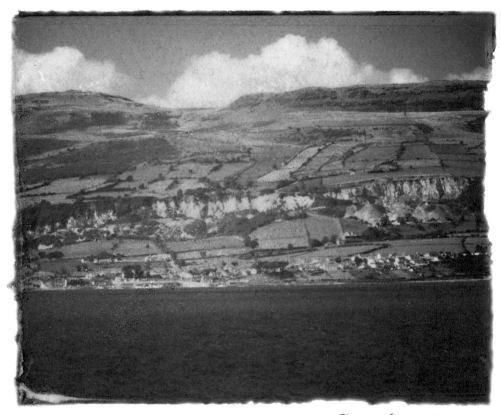

Coastline, Antrim

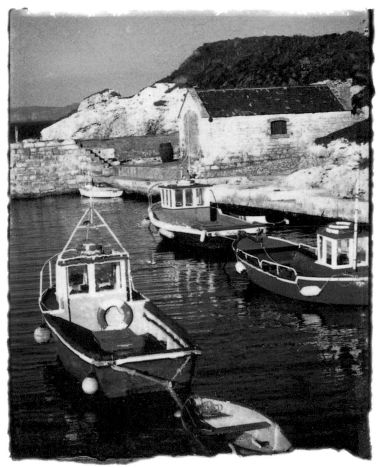

Harbour, Ballintoy

Upper Lough Erne, Fermanagh

I knew the stars, the flowers, and the birds,
The gray and wintry sides of many glens,
And did but half remember human words,
In converse with the mountains, moors, and fens.
-John Millington Synge

Countries are either mothers or fathers
and engender the emotional bristle
secretly reserved for either sire.
Ireland has always been a woman,
a womb, a cave, a cow, a Rosaleen, a sow,
a bride, a harlot, and, of course,
the gaunt Hag of Beare. -Edna O'Brien

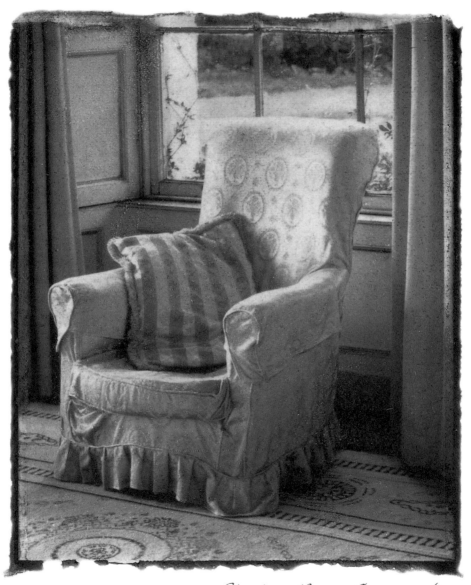

Sitting Room, Crossmolina

These Irish country houses...stand up in the country, gaunt and fortress-like, their windows looking blankly over bog and field and mountain, as the ancestors of those who built them might have looked over this country which they were to conquer but never possess. - Pamela Hinkson

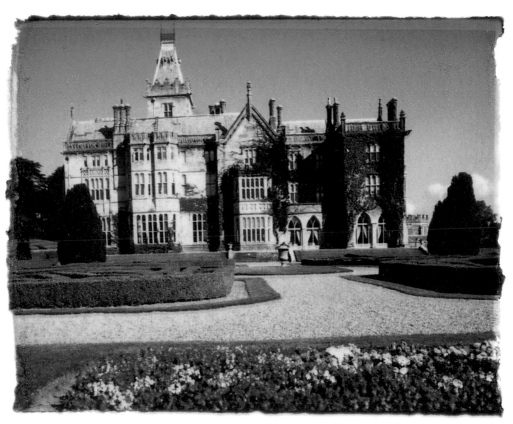

Manor House, Adare

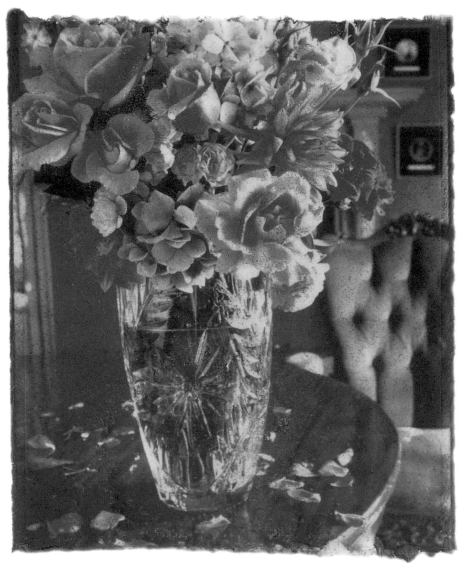

Garden Bouquet, Cashel

The studio was filled with
the rich odour of roses, and
when the light summer wind
stirred amidst the trees of the
garden there came through
the open door the heavy scent
of the lilac, or the more
delicate perfume of the pink
flowering thorn.
Oscar Wilde

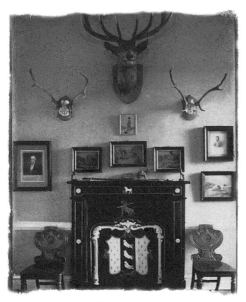

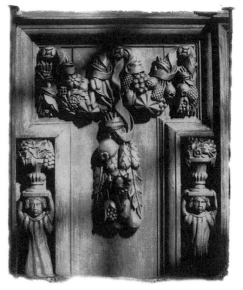

Mantle, County Mayo Dining Room, Adare

The artist, like the God of the creation, remains within
or behind or beyond or above his handiwork, invisible,
refined out of existence, indifferent, paring his fingernails.
– James Joyce

Georgian Parlour, Crossmolina

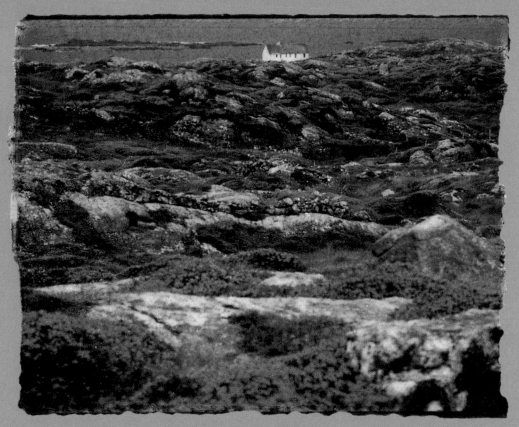

Roundstone, County Galway

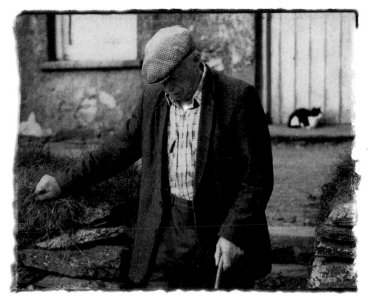

Elderly Man, Dumore Head

In age, body swept on, mind crawls upstream
Toward the source; not thinking to find there
Visions of fairy gold—what old men dream
Is pure reinstatement of the original theme;
A sense of rootedness, a source held near and dear.
-Cecil Day-Lewis

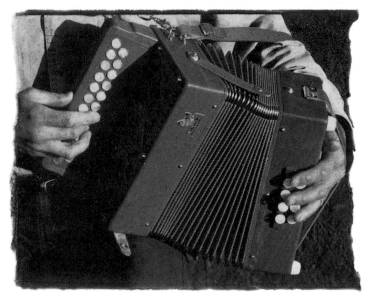

"The Lark in the Morning," Cliffs of Moher

Land of Heart's Desire,
Where beauty has no ebb, decay no flood,
But joy is wisdom, time an endless song.
—William Butler Yeats

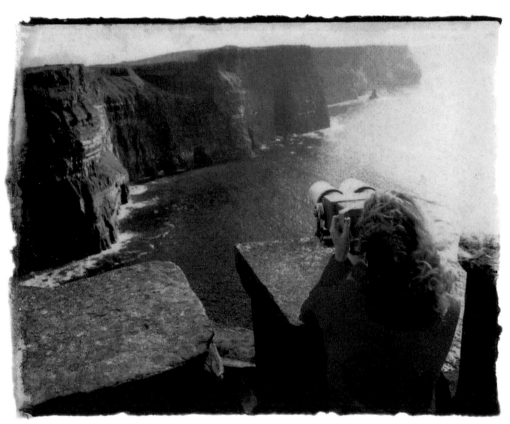

Vista, Cliffs of Moher

Merchant's Sign, Clonakilty

When money's tight and is hard to get
And your horse has also ran
When all you have is a heap of debt
A pint of plain is your only man.
-Flann O'Brien

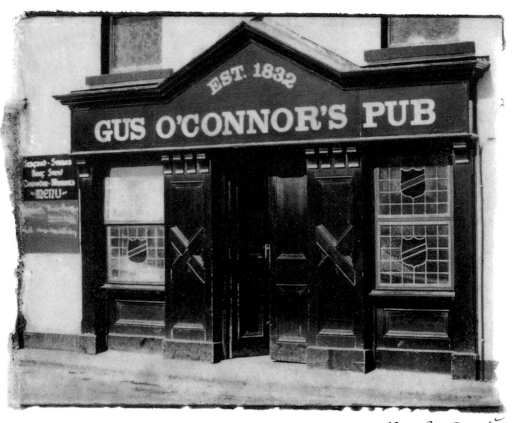

Facade, Doolin

O Ireland my first and only love
Where Christ and Caesar are hand and glove!
~ James Joyce

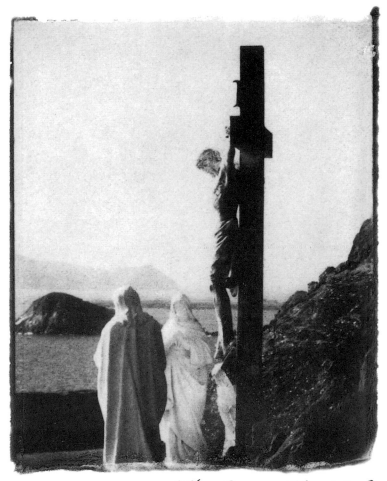

The Cross, Slea Head

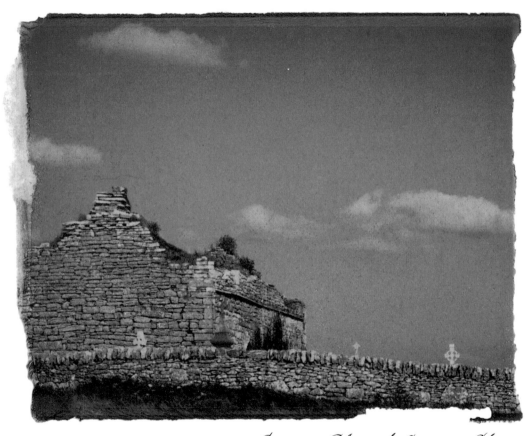

Carran Church, County Clare

Such ancient monuments worn by time and rain stand in witness and remind as does the stone of which they are, that you live only brief seconds of a life. - J. P. Donleavy

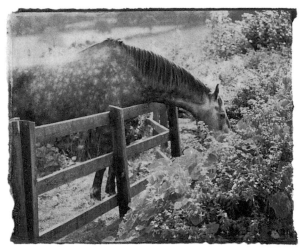

Connemara Pony, Ballyvaughan

I watched this field for forty years and my
father before me watched it for forty more.
I know every rib of grass and every thistle
and every whitehorn bush that bounds it. . . .
This is a sweet little field, this is an
independent field that wants eatin'.
–John B. Keane

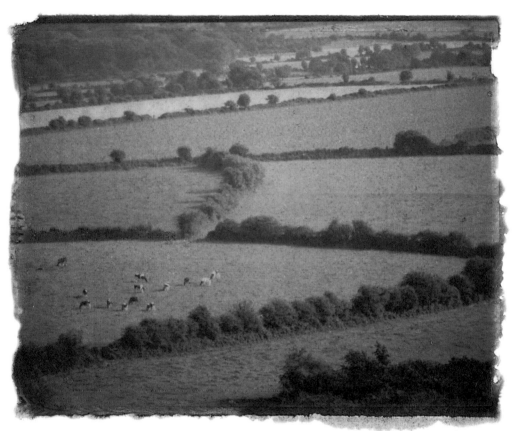

Landscape, Rathcoole

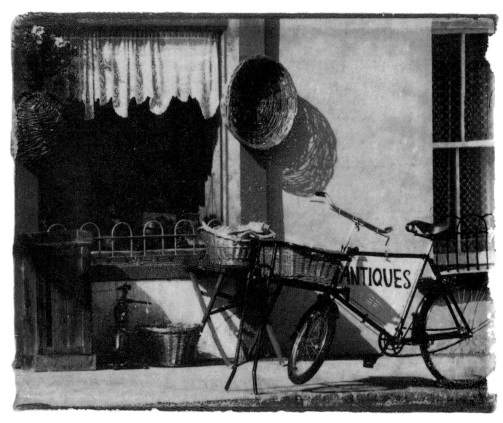

Storefront, Lahinch

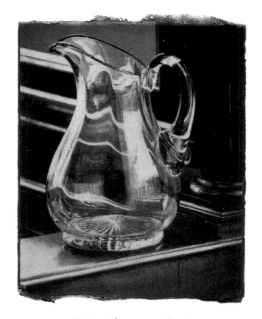

Old Crystal, Bantry

There is no present or future,
only the past happening
over and over again, now.
- Eugene O'Neill

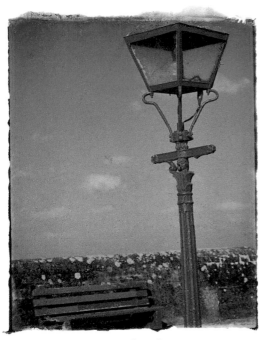

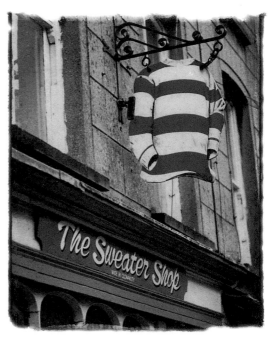

Streetlight, Kinvarra · Storefront, Clonakilty

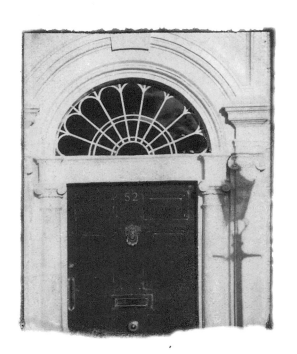 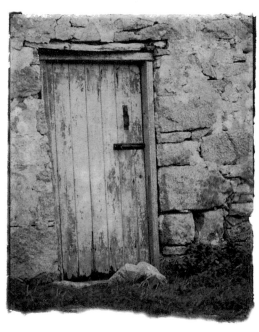

Georgian Fanlight, Dublin Farmhouse Door, Connemara

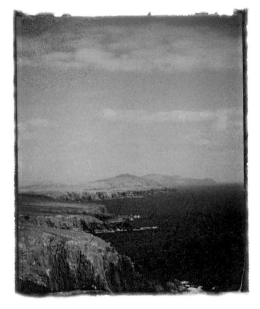

Seascape, Dingle Bay

Did sea define the land or land the sea?
Each drew new meaning from the waves' collision.
Sea broke on land to full identity.
– Seamus Heaney

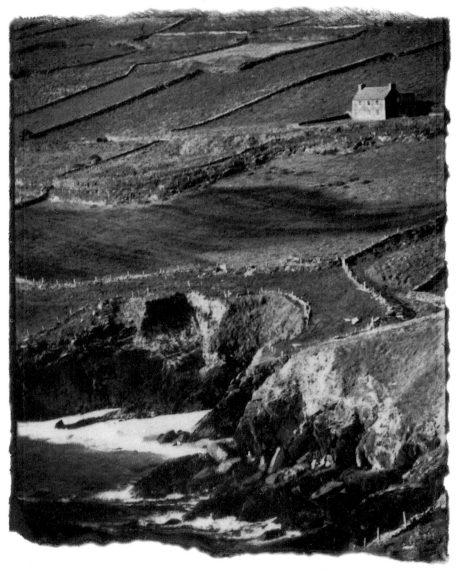

Coastline, Dingle Peninsula

Two shorten the road.

— Irish Proverb

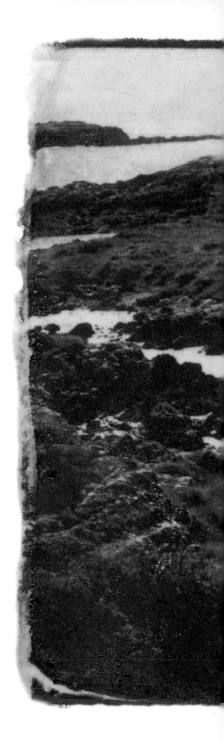

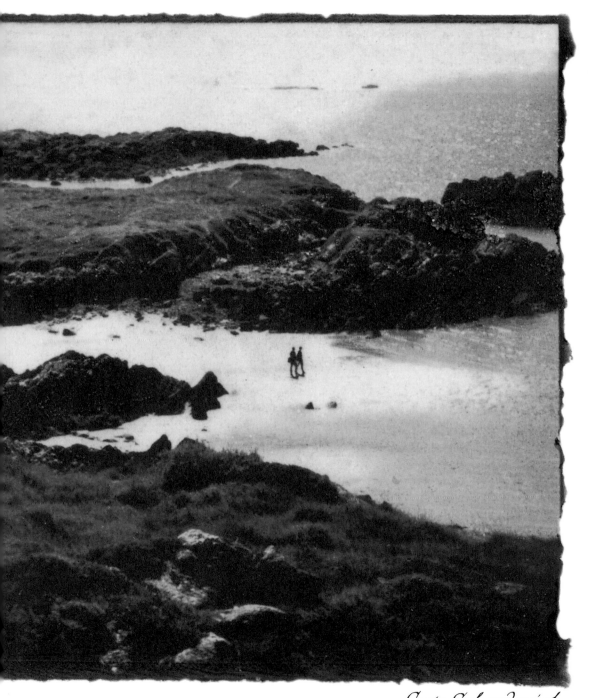

Cove, Caherdaniel

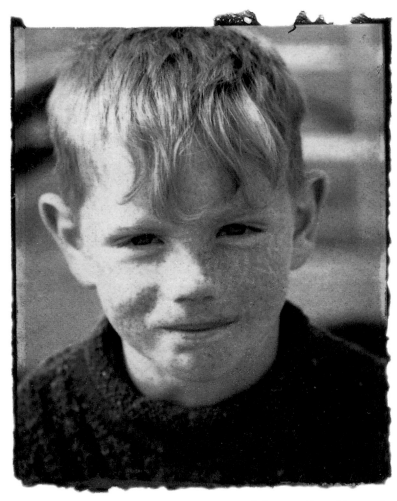

Ian Kennedy, Dingle

Come away, O human child!
 To the waters and the wild
With a faery, hand in hand,
 For the world's more full of weeping,
Than you can understand.
 – William Butler Yeats

Ireland, Sir, for good or evil,
is like no other place under heaven;
and no man can touch its sod
or breathe its air without becoming,
better or worse. – George Bernard Shaw

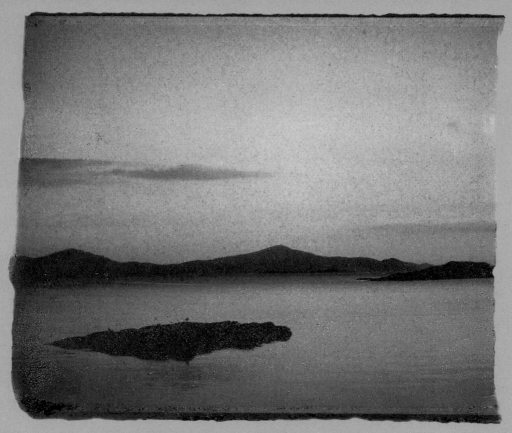

Seascape, Dunmanus Bay

BIBLIOGRAPHY

Boland, Eavan. *Outside History, Selected Poems 1980-1990.* New York: W. W. Norton, 1990.

Cahill, Thomas. *How the Irish Saved Civilization.* New York: Doubleday, 1995.

Connery, Donald. *The Irish.* New York: Simon and Schuster, 1968.

Day-Lewis, Cecil. *The Whispering Roots and Other Poems.* New York: Harper & Row Publishers, 1970.

Donleavy, J. P. *A Singular Country.* New York: W. W. Norton, 1989.

Giraldus, Cambrensis. *The Topography of Ireland.* London: G. Bell, 1894.

Heaney, Seamus. *Death of a Naturalist.* London: Faber and Faber, 1966.

Hinkson, Pamela. *The Light on Ireland.* London: Frederick Muller Ltd., 1935.

Joyce, James. *Collected Poems.* New York: Viking Press, 1937.

 Portrait of the Artist as a Young Man. New York: Viking Press, 1964.

Keane, John B. *Three Plays.* Dublin: The Mercier Press, 1990.

Knopf, Alfred A. *Knopf Guides, Ireland.* New York: Alfred A. Knopf, Inc., 1995.

Le Garsmeur, Alain; McCabe, Bernard. *W. B. Yeats Images of Ireland.* New York: Macmillan Publishing Company, 1991.

Levin, Henry, editor. *The Portable James Joyce.* New York: Penguin Books, 1947.

Little, Mary Wilson. *A Paragrapher's Reveries.* New York: Broadway Publishing, 1904.

McMahon, Sean. *A Book of Irish Quotations.* Dublin: The O'Brien Press, 1984.

Morris, Jan, and Paul Wakefield. *Ireland, Your Only Place.* New York: Clarkson N. Potter, Inc., 1990.

Morton, H. V. *In Search of Ireland.* New York: Dodd, Mead & Company, 1944.

O'Brien, Edna. *Mother Ireland.* New York: Harcourt Brace Jovanovich, 1976.

O'Brien, Flann [O'Nolan, Brian]. *At Swim-Two-Birds.* New York: Pantheon, 1939.

O'Faolain, Sean. *The Irish.* Middlesex: Penguin, 1947.

O'Neill, Eugene. *A Moon for the Misbegotten.* New York: Random House, 1945.

Shaw, George Bernard. *John Bull's Other Island.* New York: Brentano's, 1910.

Sheehan, Patrick Augustin. *Glenanaar.* New York: Longman's Green and Co., 1905.

Synge, John Millington. *The Complete Works.* New York: Random House, 1936.

Wilde, Oscar. *The Picture of Dorian Gray.* New York: Penguin, 1991.

ACKNOWLEDGMENTS

You hold in your hands the third book in my Dreams *series. No project evolves without the help of others, or without pitfalls, and this one has ample representation in both departments. Four days into my maiden voyage to Ireland, I collided head-on with a truck in front of the mystical Jerpoint Abbey in County Kilkenny. Dr. MacNally, Dr. Mickail, and nurse Denise Blanchfield of St. Luke's General Hospital in Kilkenny tenderly and expertly taped and stitched me together for the journey home. With equal parts magic, humor, and skill, Dr. Douglas Ousterhout of the San Francisco Institute of Plastic Surgery returned me to my original state. My family, Susan, Marika, and Milan, and my parents, Marilyn and Jerome, lovingly made my convalescence a comfortable and speedy one, and within six weeks I was ready to return to Ireland. It is my pleasure to thank Ruth Moran and Orla Carey of the Irish Tourist Board, Joe Lynam of Bord Failte in Dublin, Mae Beth Fenton of the Northern Ireland Tourist Board, British Midland Airline, Aer Lingus, Commodum Art & Design in Dingle, storyteller and guide Nigel Ness, Karen Kaplan, Robert Oliker, Ray Tomaselli of Leica, and Felicity Keane of* Gourmet *magazine. I am also pleased to thank Lesley Bruynesteyn, editor, Michael Carabetta, design director, and Jack Jensen, president, all three of Chronicle Books, who together blew gusts of fresh air into my spirit and into this book.*

Jennifer Barry Design would like to thank the following individuals for their support on this project: Blake and Doris Hallanan, Kristen Wurz, Tom and Aidan Johnson, Ivy Glick, Jane Dill, Edna O'Brien, Jin Auh, Conger and Meg Fawcett, Marta Hallett, Kristen Schilo, Maura Carey Damacion and special thanks to Jennifer Ward and Carole Vandermeyde whose early involvement made this book possible and a joy to create.

STEVEN ROTHFELD *has created the images for several books, including* Italian Dreams, French Dreams, Savouring the Wine Country, Nancy Silverton's Breads from the La Brea Bakery, *and* Patricia Wells' Trattoria. *His work has appeared in such publications as* European Travel & Life, Bon Appétit, Gourmet, Departures *and* Travel & Leisure *magazines.*

ABOUT THE CALLIGRAPHY
This modernized Celtic script is based on a Carolingian hand from the eighth century and an Irish half-uncial from the sixth century. San Francisco calligrapher Jane Dill has personalized and updated these historic scripts while keeping the flavor of the ancient Celtic forms.